All black cats are not alike.

ALL BLACK CATS

ARE NOT ALIKE

By Amy Goldwasser and Peter Arkle

CHRONICLE BOOKS

SAN FRANCISCO

Library of Congress Cataloging-in-Publication Data available.

ISBN: 978-1-4521-5871-6

Manufactured in China

MIX
Paper from
responsible sources
FSC™ C008047

10 9 8 7 6 5 4 3 2

Chronicle Books LLC
680 Second Street
San Francisco, California 94107

AllBlackCats.com

Contents

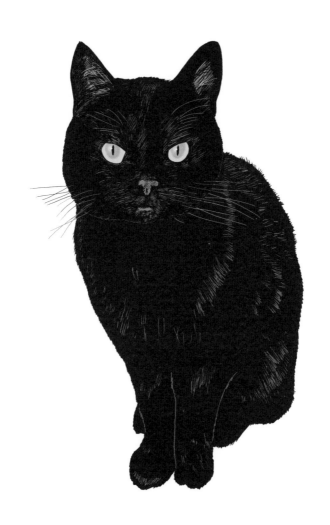

Foreword
A Q&A with Mimi Goldsparkle

The (round) face of this book, Mimi Goldsparkle was born somewhere near Hudson, New York, circa 2005. Goldsparkle rose to fame after landing the lead in a short film ("The Pop Star") for the Modkat Litter Box. She currently lives in downtown Manhattan, where she has two people, Amy Goldwasser and Peter Arkle (aka Studio Goldsparkle), and avoids an angry, stripy velociraptor of a cat, May "Mayday" Goldsparkle.

In a rare sit-down, the performer turned author and advocate for the All Black Cat (note: singular) talks about her journey and her first literary endeavor.

When were you happiest?
When that other cat (and the other cat before that cat) didn't live here and it was just me.

What is your greatest fear?
Not being able to provide for myself.

What is your earliest memory?
Nipples.

What is the trait you most deplore in yourself?
I cannot seem to gain weight.

What is the trait you most deplore in others?
Sneezing.

What was your most embarrassing moment?
Being caught faking a broken leg—all the way to the vet's—in order to get attention.

What is your most treasured possession?
All of Amy and Peter's PIN numbers.

Who would play you in the film of your life?
Alan Cumming or Idris Elba.

What is the worst thing anyone's said to you?
"You look just like my [name of other black cat here]."

What is your guiltiest pleasure?
Tinder.

When did you last cry, and why?
When Joan Rivers died.

What's the closest you've come to death?
I was alone and starving, in the middle of a baseball diamond in the pouring rain—just four months old, pregnant and homeless and nothing to live for.

To whom would you most like to say sorry, and why?
To Hello Kitty (she knows why).

If you could bring something extinct back to life, what would you choose?
Guerlain Divinora lipstick in #480.

What or who is the greatest love of your life?
Corners.

What does love feel like?
Corners.

How often do you have sex?
Have you ever seen a cat penis?

What is your most unappealing habit?
Sharing.

What did you want to be when you were growing up?
Anna Wintour.

If you could edit your past, what would you change?
The 2000 presidential election.

What was it like to cross that personal-professional line—to both live and work with Peter and Amy?
Dinner was late.

Most challenging part of making this book?
For a brief stretch it seemed my collaborators were entertaining the idea of including 49 other ABCs. Other ABCs! We had a good laugh over that one. [Ed note: Shhhhhh.]

And your favorite part?
May hates it.

A Note on the Depiction of Cats:
All characters appearing in this work are somewhat fictitious, as
they are cats. Any resemblance to real All Black Cats, living or
dead, is purely intentional. Names were not changed. Portraits
were drawn from photographs; bios were inspired by true stories.
The authors made every human effort to maintain factual accuracy
surrounding subjects who cannot speak with humans.

Introduction
A Human Perspective by Studio Goldsparkle

So that we may now talk freely about All Black Cats—or at least the 49 other All Black Cats in this book—we waited for Mimi to leave the room. She has now climbed her ladder and retired to her emo loft, high up at Home Goldsparkle, where she is literally positioned above all other creatures.

She likes it that way. Mimi is an odd little alien in a black fur coat. She's entirely unique, entirely eccentric, entirely inscrutable.

Just like every one of the one-of-a-kind All Black Cat (ABC) characters you're about to meet.

In the case of Mimi, we had rare access to our subject, an inside perspective on the inside of her big, round head. To uncover the most extraordinary and charming qualities in each of the 49 others—including our late loverboy ABC Sonny Goldsparkle, unavailable for interviews since Valentine's Day 2005, see page 46—we relied on the interpretations of their humans. It was up to these embedded reporters what they chose to highlight, what they chose to ignore, what they chose to admit or omit, reject or project about the All Black Cats they know best.

Meaning we like to think this book is about people as much as it is about cats.

We also like to think that this book is the closest we could bring a cat book to non-fiction. These are 50 real ABCs and their 50 true ABC stories. They live all over the world, from New York City to the countryside of Grossaflloltern, Sydney to Scottsdale, the Netherlands to the top of the cable box. They live for cheese, plastic, French bread. Up a tree, in a beard, on the Big Island, on a sailboat, on their own terms. At war and at peace. With a goldfish, a German Shepherd. One kidney, two dads, three other ABCs.

Every ABC in this book came out of our 2015 Kickstarter campaign—which is how nearly every one of them came to us as well. Of the 50, we've only had the pleasure of meeting three in person (in cat?): Mimi, Sonny, and Vano (page 116), who was kind enough to invite us over one night, ostensibly for dinner but really to show us how he works the icemaker built into his refrigerator.

See? Odd little aliens.

Aliens and individuals, as confirmed by the collection of personalities—some may say personality disorders—you see here.

All black cats are not alike. Who could possibly think otherwise?

The answer—and the inspiration for this book—is that there are people out there, even people we adore most, who, on the receiving end of our "Have A Spectacular 2015" New Year's card (see right), accused us of featuring not Mimi, our ABC, but *their* ABCs. (Of the four of us, only Peter regularly wears spectacles.)

All Black Cats are not alike, people. To illustrate this for one household, Peter assembled a quick identification guide:

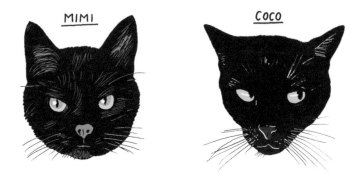

It got us thinking about all of the Mimis and Cocos out there. And it got us thinking that a celebration, a compilation, around ABCs was due.

Plus, we like few things more in life than drawing/looking at cute cats. Plus, Mimi was self-mutilating, licking a lot of her own fur off that winter due to sharing a home with newish May. We thought she could use a boost.

Plus, Peter is an illustrator and Amy is an editor-writer, and we were getting tired of everyone asking us when we were going to do a book together. In our real lives we have few chances to collaborate with each other and even fewer to collaborate with our cat.

We decided it was time for the first lovingly hand-drawn, hand-lettered tribute to the wild range of personality, originality, charisma and character of 50 highly-individual All Black Cats.

On January 27, 2015, we launched our project on Kickstarter, with the goal of raising $28,000 and 48 All Black Cats. (We'd cast only two: Mimi and Sonny.) Our reward tiers offered backers the options of guaranteeing a place for the ABC of their choice in the book, sponsoring an ABC who we knew was up for adoption, or nominating an ABC who would be vying for whatever number of places remained.

We had a blast. We nearly immediately fell into a wonderful, strange, overwhelming all-black hole of All Black Cats and their people. We met hundreds of both. We met someone who campaigned hard to include his girlfriend's cat—who was eventually revealed to be not at all black by anyone's definition. Someone else tried to put a human girl in the book. We got ABCs with videos, ABCs with soundtracks, ABCs with sweaters, ABCs who write in the first-person. We started to feel like we knew the ABCs gone missing, the ABCs in memoriam, the ABCs with medical conditions and the ABCs with people with medical conditions.

We mourned the losses, cheered the adoptions, blew off work. We knew which Salem was male, which female. We started following Penelope Kitten on Twitter. We sent out weekly project updates, initiated Black Fur Fridays. On Sundays, we'd go home and see ABCs in the faces of *Game of Thrones* characters.

In the end, we had 31 ABCs with secured places in the book. For the 19 remaining spots, we were many cats deep.

Those were some of the most hotly-debated, difficult work-life decisions we'll hope to ever have to make.

Our final selections were based, above all, on diversity—basically the cats who would best serve our thesis. But of course we wanted to keep them all. We have no doubt there are an infinite number of equally distinct, delightful ABCs out there to fill an infinite number of books.

We can also now assure you, with some authority, that the 50 All Black Cats on these pages are not alike.

In fact, about the only thing they have in common is that they—like all cats—are singular wee weirdos, each in their very own ways.

Get to know someone, ask the right questions, and we all are.

Enjoy.

~~Plates~~ CATS

Master is a sleeper agent.

Like the Russians say, you don't choose the cat, the cat
chooses you. Lars and Irene named their gutsy wee thing
for the walking-talking tram-riding devil's associate cat in
Bulgakov's *The Master and Margarita*. When they brought
him home a few years ago, he fired out of the box, puked,
put his tail in the air and decided that this would do. He
thinks it's extremely rude when guests don't say hello to
him. He spends his weekdays in Long Island City, Queens
(where he has agreed to use the toilet), and his weekends
in the country by a lake. He is no good in a canoe.

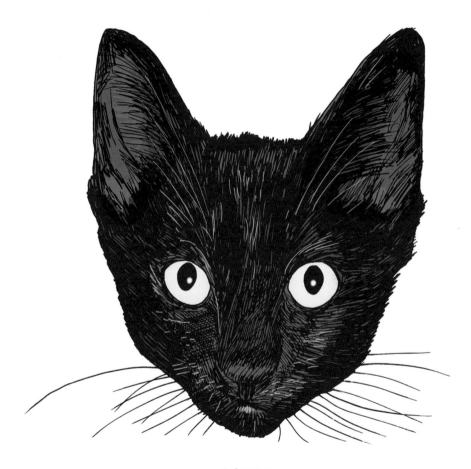

MASTER

Lucky regrets not flossing.

A black cat book is not a black cat book without a
Lucky. Full custody of this one was ceded in a divorce
to Christy, who, in 2007, was so taken with his sleek look,
aloof behavior and auspicious name that she resisted
heavy promotional efforts by shelter workers on behalf
of a black-and-white rival. Lucky has not had much luck
in terms of keeping his teeth; only one fang remains.
For several years he reluctantly shared his Brooklyn home
with All White Cat Wafu. Lucky could barely conceal his
glee when she died. He's been known to hump faux fur
blankets, and when he is especially displeased (like
when Christy leaves on vacation), he poops in the
bathtub. This is somehow both naughty and considerate.

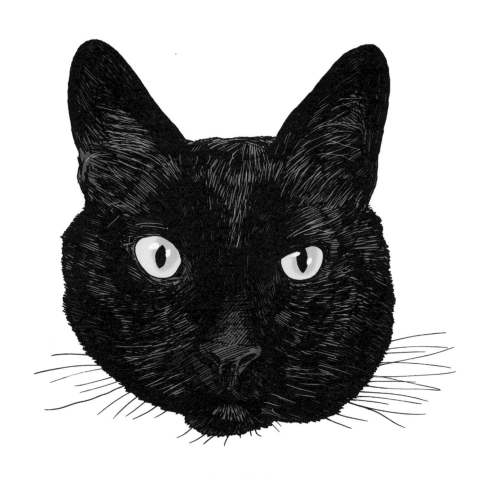

LUCKY

Bad Cat is a former prince.

Bad cat! At the shelter, this cat was the small, scared
one that hid. Jessie and Jesper Anderson, there seeking
another ABC after the death of their Munster, figured
How bad could he be? They named him Prince Myshkin
(from *The Idiot*). That was before he howled in the middle
of the night for six months straight every time he went
to the litter box because he'd get lost on the way back
to bed — a 20-foot straight shot across an open loft,
very confusing. Bad cat! He was renamed at 2 a.m. He
spent the night before Jessie and Jesper got married at
the emergency vet, resulting in a surgery that cost more
than their wedding. Bad cat! He likes Cheetos, cracks
between cushions rather than cushions, and attacking
Ducky, his gentle-giant 18-pound (equals three Bad Cats)
tuxedo housemate. He dislikes complexity. He recently
moved to Portland, Oregon.

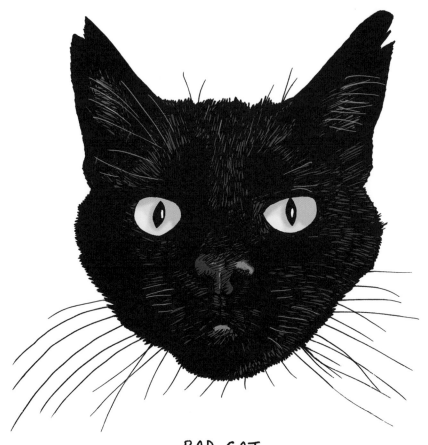

BAD CAT

Princess (of Long Island) fishes for compliments.

When the house is nice and dark and everyone is in bed—people Paul, Patrice, Brian, Matthew, Christine, Colleen, blonde brother cat Maxwell and Lab-Retriever mix Sadie—Princess likes to take the dish towel that hangs on the stove to another room and howl and howl until someone tells her she's a good girl. She and Maxwell were to live there for a week as kittens (on loan from rescuer Aunt Irene). That turned into 13 years. Her fur is like velvet but she is a little overweight. Princess looks like a raccoon from the back because she waddles.

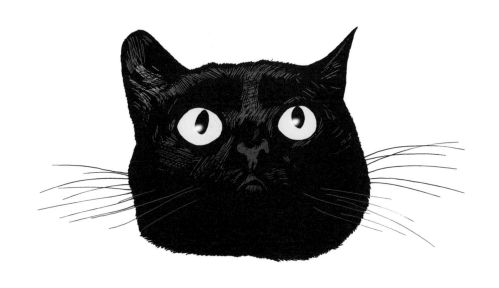

PRINCESS (OF LONG ISLAND)

Blackness/BatWing is guilty.

Blackness/BatWing is responsible for the missing
hamburger patty. At two-and-a-half, he's the baby of
a houseful of animals just north of Pittsburgh: four cats
(Jynx, Wibbles, Kowalski, Effie) and two German
Shepherds (Ziggy, Morgan). He sometimes comes to visit
All Gray Cat Baboo and Rhodesian Ridgeback puppy
Rasko. He does *not* like to be snuck up on and will jump
10 feet in the air if this happens. He likes donuts, car
rides and Christmas. He's been seen wearing a knit scarf.

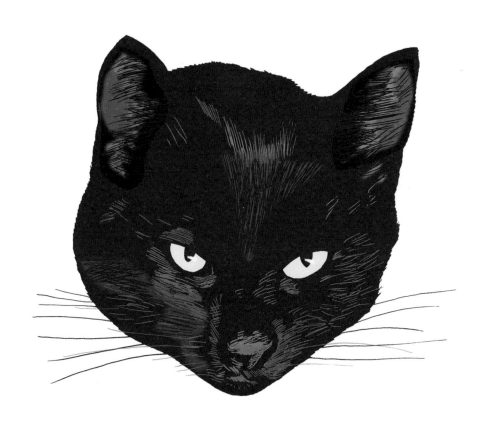

BLACKNESS/BATWING

Darkness is a licker.

Of the five female cats who share a home with Jesse
and Amanda in Kona, on the Big Island, Hawaii, Darkness
speaks the most loudly. Though she meows the least.
Most of her talking is done with her tail. When TT, Pudgy,
Munchie or Kookoo approaches, Darkness will first take a
swipe—and then pull the cat close to clean her head and
ears. She drinks from the sink, which gets water up her
nose. She dislikes strangers, who rarely see her anyway.

DARKNESS

Church is a goth.

Church avoids eye contact, hunts lizards and goes into
a rigid trance while listening to doom metal on an old
record player in a little seaside suburb of St. Petersburg,
Florida—in a dark, end-of-the-street corner house that is
decorated year-round in Halloween gore. He was named
after the cat in *Pet Sematary*. He has six toes on each of
his front paws and tries to claim ancestry back to the
days of Hemingway, when polydactyl cats ruled Key West.

CHURCH

Nox takes no shit.

Delightful weirdo Nox makes people look at her butt.
She sleeps in Kyle's beard and steals things — jewelry,
grilled chicken, knitting and sewing tools — that are often
found buried in the litter box. The tiny 2-year-old mouser
plays with humans Keira and Kyle, dogs Buster and
Ripley, cat Fat Lumen and dead things, in a 75-year-old
house in the heart of Indiana. She is a risk-taker: trying
to jump into a hot oven, hanging out in the dishwasher,
crawling into walls. When Keira found her — dirty and
hungry under a faded blue late-'80s Aerostar minivan
that was leaking oil — Nox yelled at her until Keira did
what she wanted. Nothing has changed since.

NOX

Fergus talked shit.

Chicago-born Fergus liked his water served in a pint glass, could carry on a conversation as long as you were willing, and loved almost everyone (exception: an old boyfriend of Julie's). He lived to a Booker T. & the M.G.'s soundtrack and the chatty old age of 17, with Julie and Dan. In 1992, when Julie, 17, had to lie about her age to adopt him, Fergus was one of three ABC kittens at the shelter: one was lying down, one was standing up, and the future Fergus was standing on top of the one that was lying down. He's one of four Julie-Dan ABCs in this book. (See also Alfie, Harold and The Count.)

FERGUS

Penelope Kitten is on duty.

Penelope Kitten lives in Los Angeles. Of course she does.
She is technically no longer a kitten but does not advertise
this. And anyway, she's the still the youngest, the spoiled
little sister to cats Marcy, Hamlet and Scooter. Penelope
Kitten loves Hamlet. She does not care for Marcy. She
does not meow. She plays police officer, a by-the-book
kind of cop who takes a lot of lunch breaks. She patrols
the perimeter and hallways of the house and lets Cynthia
Mance and Freddy J. Nager know in her squeaky voice
if anything is amiss. When the offender is a cat, she will
not hesitate to whap him or her on the head.

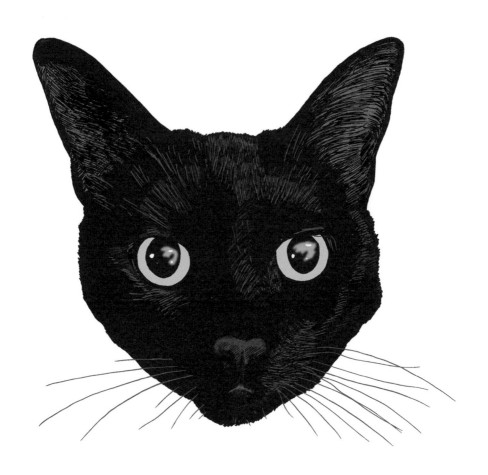

PENELOPE KITTEN

Sashi is scheming.

A shy beauty of Siberian descent, Sashi lives in Park
Slope, Brooklyn, with four humans: two large, two small.
She yells at the woman in the morning and the man at
night. She is starting to manipulate the kids. Sashi is
15 years old but looking great, often mistaken for 12.
She enjoys freeze-dried chicken by candlelight and
full-body rubs. She does not enjoy overachievers, beef
or pork.

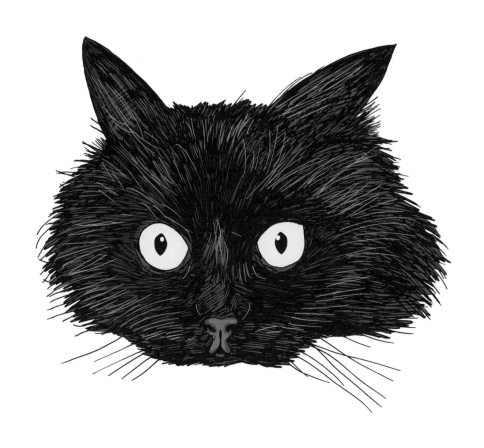

SASHI

Coco was hot.

Coco lived in the greater Los Angeles area, where her urn is now in the wine rack. She met her man Steve in the mean suburbs of San Diego, sauntered up, locked her big eyes on him—then for the rest of her 17 years resented anyone who got too close to him, including his girlfriend-fiancée-wife Dawn. (Dawn acknowledges that she submitted a late-'90s photo, when Coco had gained her freshman fifteen, as portraiture reference.) Coco liked tuna and she liked to sing, especially "On Top of Old Smoky." She did the call and response.

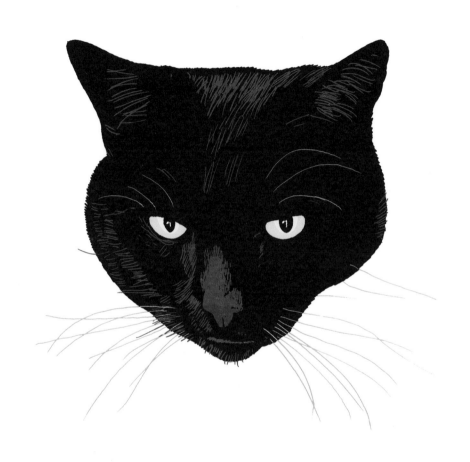

COCO

Vincent was upwardly mobile.

Originally caught up in a feral cat sweep—trapped, neutered, Van Gogh ear-tipped and released—Vincent quickly decided he was done with that life. He briefly crashed in the little apartment Cindy and Gary had set up for him in a storage shed, but soon tried to sneak into their home in Sonoma wine country. The streets were not for him. In fact, he did not even like the floor. To avoid it he would traverse from kitchen table to woodstove to desk to bookcase to end up on the couch. When he did walk on the floor, he had a strange gait, kind of a Popeye strut. He died in May of heart disease, a fighter to the end.

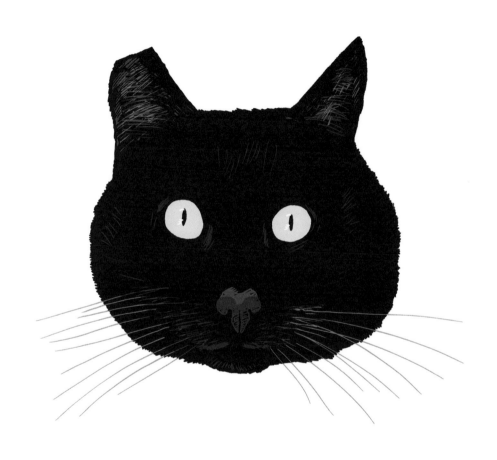

VINCENT

Hugh is putting together a TED Talk.

A fan of feathers and food, Hugh—son of a gigantic
and mysterious ABC stray—lives in Indianapolis with
two people and one cat brother. He can be neurotic
about licking plastic and has a lot to say.

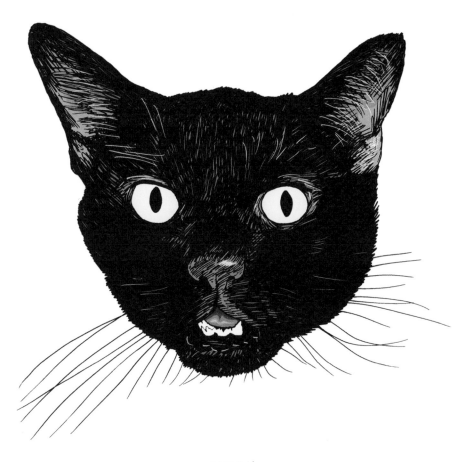

HUGH

Sonny was a lump.

Total mellow dude and loverboy Sonny lived with
The Goldsparkles in the East Village of NYC, until—
sadly but appropriately—Valentine's Day 2005, when
he curled up on their bed and died young. They like to
think it was of contentment. He was impressively happy
and lazy and heavy and unskilled in the ways of cats.
He would fall off large, secure surfaces. He didn't clean
himself much, so he was often mucky. Once he got his
claw stuck in the spine of a dictionary, which he dragged
around for quite a while until he fell asleep next to it,
unbothered and still attached. Peter to this day swears
that one night at bedtime Sonny looked right at him and
said, slowly, deeply, "Alllllright." Beyond fur color, he had
not a single thing in common with future chic and shiny
size-zero ABC heiress Mimi Goldsparkle.

SONNY

Salem (the Younger) is drinking your water.

Sleek 2-year-old Salem, who plays with bottle caps,
lives with Cat (Cat!) and her fiancé Mike in the Financial
District of Manhattan—where he will always drink out
of your glass, never his bowl. He is likely right now
stranded on top of a giant mirror in the living room.

SALEM (THE YOUNGER)

Salem (the Elder) treated interns poorly.

One day in Belgium more than 19 years ago, Eric found
Salem at the front door, asking to come in like she
had always lived there. Then she did, making sure she
and all others in the house — Eric and his wife Isabelle,
their daughters Garance and twins Amandine and Julie,
Mishka the cat, Pirate the dog — lived on her terms. She
ran after the German Shepherd, who was afraid of her.
She outlasted many a naïve newcomer cat, showing at
least one of them less survivor-wily than she how
comfortable it was to hang out in the middle of the street.
Still, she loved to be hugged and cuddled. She died this
spring, quite possibly in her 20s.

SALEM (THE ELDER)

Koa wears black socks.

Valencia, California-based Koa, who hides when he hears the doorbell, likes stealing treats from the other cats (Kahana, Kamea, Kalani), watching Clippers games with his dad and watching the squirrels outside with whoever. He was adopted as a tiny kitten who was so attached to the Persian purebred (Kahana) his people had originally intended to rescue that separation was not an option. Now four, he's very fat, but his head didn't grow to match. He is at war with All Black Socks— but only black socks. Wear any other color and he doesn't care. Wear black ones and he will bite toes until there's a hole.

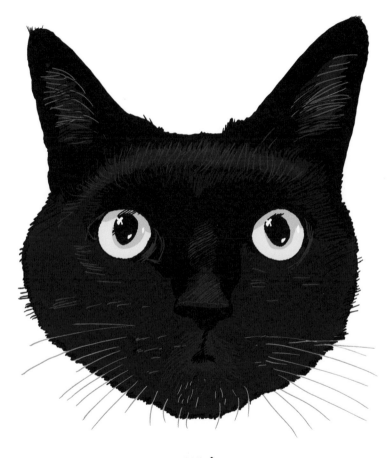

KOA

Ronaldo wins.

When stretched out, Ronaldo is almost three feet long. In a feat of expert-level cuteness one day in April, the 13.5-pound, 3-year-old big boy rubbed up against Rebecca and flopped on his back at Meow Parlour (Manhattan's first cat café). Now a Brooklynite, adopted with his black-and-white friend Roger, he winningly fixes his slightly cross-eyed stare on Rebecca to try to wake her up before he resorts to sniffing her eyeballs. Patience is his weapon. The ultimate ninja cat, he can wait quietly forever for a human to trip over him and drop food. Or, when his younger brother is bugging him, Ronaldo will just sit and sit on Roger's head. He totally wins, every time.

RONALDO

Toet is a monster.

Dish-eyed Toet (pronounced "Toot"), who catches birds
and mice in the Netherlands, is the best monster ever.
He likes to walk through the garden with his humans,
climb the trousers of anyone in a bad mood and tell you
about his day in his very own high-pitched miiiiiieeeeeews.
Indoors, he lives with another cat, a hamster and some
goldfish. He loves to help with homework, to cuddle and
to lie around one's shoulders like a stole.

TOET

Kim is in the bath.

Not being Kardashian fans, Sara and Francis dropped
Kim's last name when they adopted her this winter —
along with orange tabby fostermate Kris — after a
Valentine's Day date at Meow Parlour. They live in
Queens, where Kim blends in perfectly with the furry
black blanket draped over a recliner. She near-disappears,
unlike a Kardashian. She is obsessed with the bathtub,
walking along the ledge, lying down in it when it's still
wet and using it as a kill corner to bring toys she's
caught (and will growl to protect). The one time she fell
into a full tub, she hopped back out and shook herself
off, no drama, no selfie.

KIM

The Count is hardcore.

An attacker of vegetables and pencils, The Count
bites everything. He was one of three incoming ABCs
(with Alfie and Harold) adopted by Julie and Dan in
Washington, DC. He hates rules. His song is "Search and
Destroy" by Iggy Pop and the Stooges. He is a survivor.
He has one kidney, one very large kidney. He has broken
his hip joint, sliced open his paw, eaten a bicycle tire
valve cap and been given an overdose of sedative that
put him in a 24-hour coma—defying surgeries, stitches,
anesthesiologists and neurologists to keep bouncing
back to his charmingly destructive self.

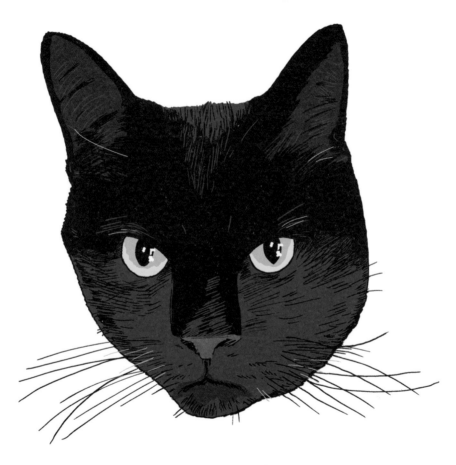

THE COUNT

Hampton was kind of an asshole.

The former ABC of a man called Fluffy—character, fixture
and tortured soul of the Chicago restaurant scene—
Hampton was taken in by Michaela and Rob seven years
ago, when Fluffy, their good friend, died and they realized
that one of the loves of his life was about to go to the
shelter. (Fluffy was young; Hampton was not.) Much like
a chef, Hampton loved cheese, mayonnaise and butter,
though he was allowed none of these. He would sit on
Rob's chest and lick his neck for an uncomfortably long
time. The All Black Cat lived a colorful life till at least 17,
surviving not only plates of drugs lying around Fluffy's
place but then the introduction of Michaela and Rob's
twin infants Kai and Knox. Hampton died this July.

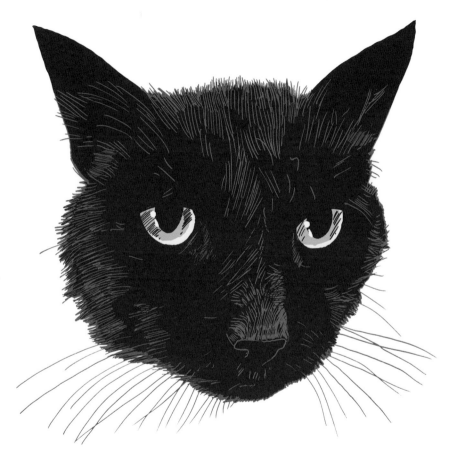

HAMPTON

Puzzles is emotional.

A kooky, supremely affectionate 6-year-old Cornish Rex permakitten—whose pink skin shows through just enough to make the odd observer or say, book illustrator, question her ABC status—Puzzles was named for her puzzling looks. Those who call her a rat are not invited back to the Los Angeles home of Dan Koeppel and Kalee Thompson, who consider their two young sons Otto and Laszlo baby brothers of the cat. Puzz is long-legged, acrobatic (she flips, she twists, she fetches), very hot (literally radiating warmth, serving as a water bottle for her achy people) and eats incredible amounts, demonstrating an astonishing metabolism for a five-pounder.

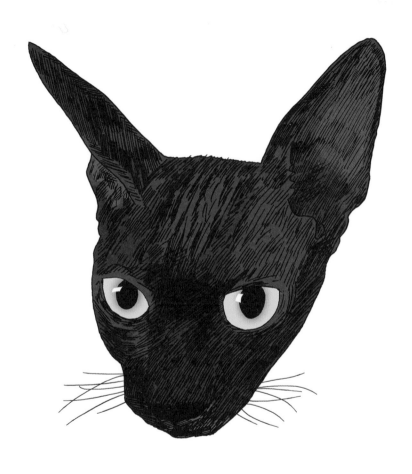

PUZZLES

Mimi has had enough attention.

MIMI

Wookie was pyramidal.

Originally one of five sick little siblings who started their
lives as urchins on the streets of San Diego, Wookie
went on to live a long, happy life — full of problem-solving,
plastic and French bread — in the home of an artist mom,
two awesome dads (dad and stepdad) and many rescued
cats and dogs. Here you might have found Wooks dipping
his paw in someone's morning coffee or walking through
a bathtub full of water. He was named for his elongated
speaking style that made him sound like Chewbacca's
mini-me at a higher octave.

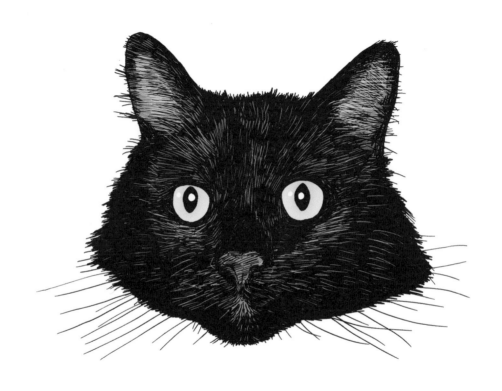

WOOKIE

Requiem was a pro.

Showman and purebred Bombay Requiem was a home
birth (dad = Moonshine, mom = Witch Hazel) in Canada
who eventually migrated to the California sunshine.
He lived with other cats, dogs, birds and horses and ate
popcorn claw stab-to-mouth. He once, feeling neglected
on the table at a cat show, stretched, put both feet up
on the judge's chest, extended a paw to give her a few
pats, some would say slaps, on the cheek—and walked
with a first-place ribbon. He left the legacy of his son
Jedi and granddaughter Nikita.

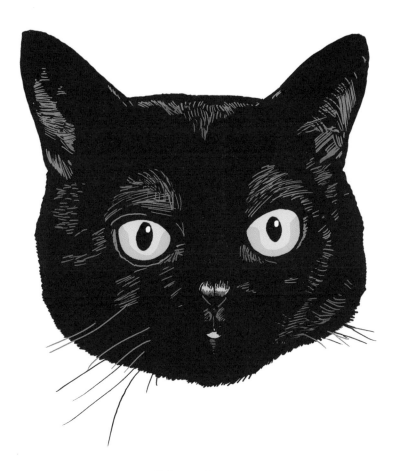

REQUIEM

Lucy/Lucifer War Machine is ticking.

Flesh and sunlight, smashing her skull into people she
deems acceptable, and sleeping with her face squashed
into a cushion are favored by Lucifer War Machine, aka
Lucy. She keeps a human companion and his wife in a
verdant realm shrouded in mists known as Seattle. Here
birds are sky-rats to be fired upon with the War Machine's
vocal barrage of anti-aircraft guns. She often tries to
stow away in luggage, unaware that deadly weapons
are forbidden. Her ear was perhaps tipped by spayers,
perhaps in part lost in a duel.

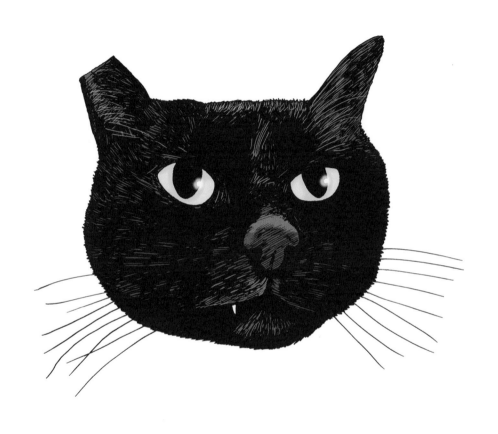

LUCY/LUCIFER WAR MACHINE

Cleo was not impressed.

Regal and petite Cleo spent the last three years of her
life in her own private suite — away from detested feline
housemates Henry and Mojo — in the master bedroom of
Lisa and Steven in a Boston suburb. (Previously: on top
of the cable box in the kitchen, where she ate, slept and
left only to use the litter.) This is how much she hated
those other cats. Plus, she was a diva. She did not say
"meow," she said "meh." Steven was her one true love.

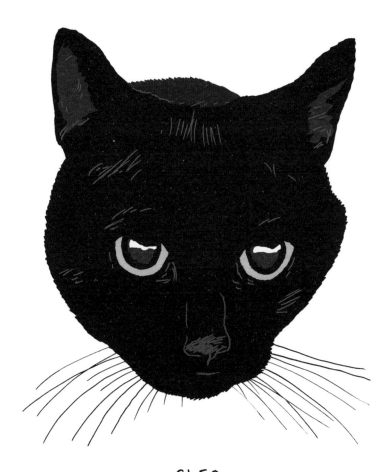

CLEO

Alfie is smart.

A quick study with a killer instinct, Alfie is believed to
be the Keyser Söze of Julie and Dan's household—
goading his half-brother Harold and The Count into
doing his bidding. The 6.5-year-old preens in his seat of
power, too, a formerly odd-looking part-tabby kitten who
by 10 months had completely transformed into a beautiful,
medium-haired ABC with a hint of ring-tailed lemur. Today
he runway-walks around with his long, fluffy tail in the air
and likes his chicken organic; he perhaps has a stylist.
He has no tolerance for wet humans or being ignored.

ALFIE

Cassie will show you the door.

Fierce and untamable, Cassie, 15, hisses, scratches,
growls — and has run off every sitter her people have
engaged for her. No one has ever returned after a first
term. The door of her luxury suite at the kennel reads
UNSOCIABLE. Originally borrowed as a mouser from
friends with a houseful of animals on the North Fork of
Long Island, Cassie has since been a city gal: NYC to
Washington, D.C., to her current 55th-floor apartment
in Chicago, where she loves sunlight, prosciutto and
drinking from the toilet.

CASSIE

AC/DC, aka A.C., hates summer.

Generally a badass, AC/DC has never once used his
litter box. Instead he uses the dog door (thanks, Lab
mix Indie) for jaunts around the neighborhood. He climbs
walls and always likes to be in on the action. Though
AC/DC is 14 and his whiskers went lack-in-black white
after a stomach surgery—related to a fight or a fall—he's
not on his legends or casino tour yet. Because AC/DC
lives with ample, mat-prone rocker hair in Scottsdale, AZ,
where it's a thousand degrees, Rachel and Bret shave
him down to a lion look every summer.

A.C./AC/DC

Ringo has just landed.

Though silky, jet-black young Ringo is an easygoing boy,
he always looks somewhat startled. When he arrived
at Meow Parlour—where he and fellow ABCs Ronaldo
and Kim were all adopted and sponsored to appear in
this book—he had a single white whisker on each side.
One day he lost one of them and seemed very upset by
the asymmetry. Until he lost the other. The 1-year-old
puppycat personality, a Taurus, likes snuggling, soccer
and yellow submarines. He dislikes magnetic anomalies.

RINGO

Spencer makes out.

Originally sickly and syringe-fed, Spencer was one of
a litter of five ABC kittens nursed and fostered by
dedicated rescuer Karen. Now 9, he lives in Westchester
County, NY, with no fewer than: one collie; one sheltie;
two feline brothers (orange/white, tabby long-hair);
three feline sisters (almost-ABC long-hair, calico, tabby);
and various transient fosters who come in from high-kill
shelters until finding forever homes. Spencer gives a lot
of kisses. He loves moths and most improbably, Matt
the mobile dog groomer.

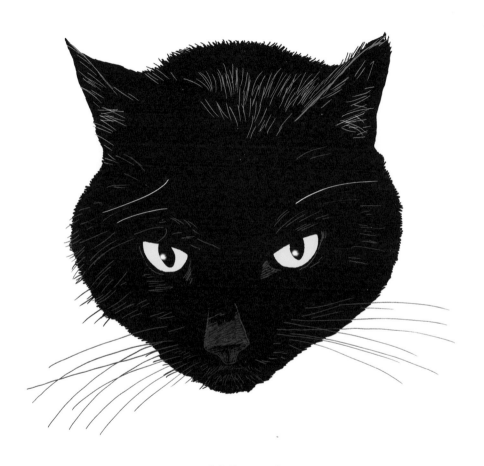

SPENCER

Tzipi wants out.

A little over a year old, Tzipi was wild as a young kitty. She hunts lizards, has managed to safely bolt from the gaze of five coyotes (as she lives next to a canyon in L.A.) and scales trees—once so far up, for so long, so no-way-down that her people ultimately had to call the LAFD. Five hunky firemen showed up, pointed to the ground and asked, Is that your cat? Tzipi, oddly enough, does not like fish. She prefers goat yogurt. Poshi, the cat she lives with, is her best friend.

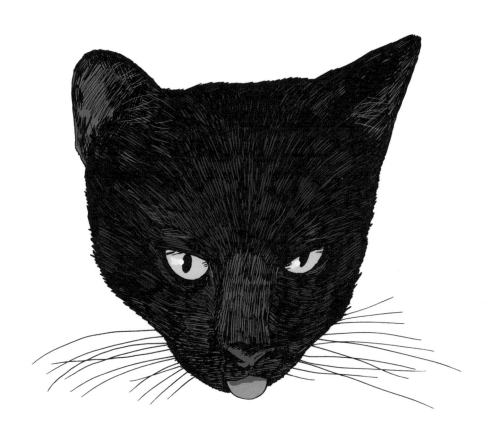

TZIPI

Yoshi wants in.

Despite the Japanese boy name, Yoshi is a 13-year-old girl. She was a stray who won the hearts of her cat-speaking people by jumping the highest of her littermates—five, six feet straight up. She was a champ dealing with the two little humans who later joined her household. She currently lives (and uses her words, with an impressive vocabulary) in the bucolic suburbs outside NYC. In an ideal scenario she is lounging on the warm floor of the upstairs bathroom eating shrimp.

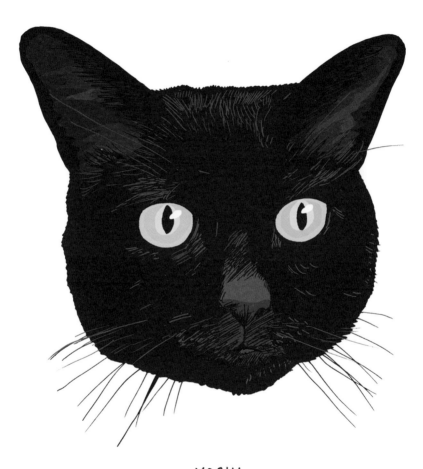

YOSHI

Pumaa knows your password.

Twelve-year-old Pumaa has recently relocated from
Bern, Switzerland, to the countryside of Grossaffoltern.
(Double letters abound.) His people Petra and Patrick
met him as a kitten, and he soon became Patrick's
second shadow, including sleeping on his stomach and
sitting in front of the computer supervising coding skills.
Pumaa hates being picked up and cuddled, though
Patrick does it anyway. He meows on command.

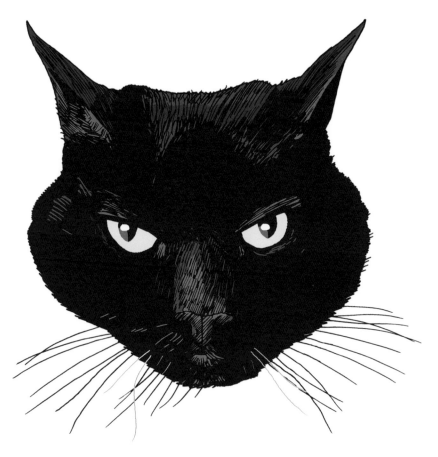

PUMAA

Monty is well-rounded.

A Bombay who does backflips, Monty—aka Vino Nobile
di Monty-pulciano and Asti Spu-Monty—was named
for his dual citizenship, being born in Montreal and
brought home at 15 weeks to Montvale Street in Boston.
He pretty much must be with Courtney and Bob and
their son Sam at all times, or at least Bob, whose face
and then toes he licks in the morning. He wishes his
ABC housemate Gracie were not past her play days, as
he has a mouse on a line on a wand that he drags around
the house alone at all hours.

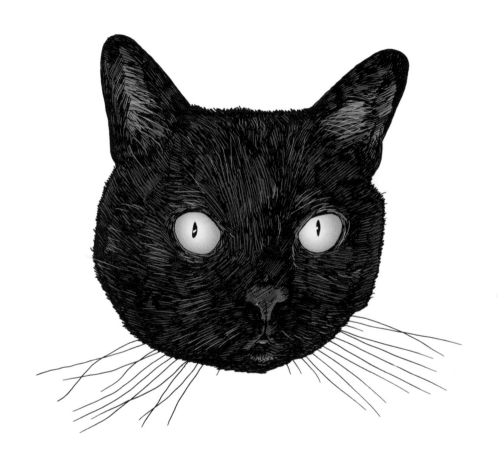

MONTY

Reginald has registered for a toaster.

Soon after Brian and Carol adopted Reginald, who
turns 2 this October, they had to put child locks on their
cupboard doors. There are few ABCs in the world who
are as determined to eat people food—or as obsessed
with toast—as Reginald. Greek yogurt does it for him too.
He lives in Sydney with Aussie older brother cat Axl,
a big ginger.

REGINALD

Harold flops.

Whatever is going on is fine by Harold. Half-brother of
Alfie and housemate of The Count (and Dan and Julie),
the laid-back 16-pounds-of-love ABC will on any
occasion just flop down stomach up in your path
looking for a belly rub. He boxes (sitting on his hind legs
throwing rapid punches with his front ones), wags his
tail when he drinks, and favors the Humid Harold method
of waking his people: sticking his nose in their ears and
breathing heavily.

HAROLD

Abby huffs.

Raised by her late ABC brother Baci, formerly annoyed
by her late ABC brother Boris and currently tolerating
ABC brother Seth, gray cat TomTom—and human servant
Michelle—Abby lives in a wooded rural retreat in Virginia.
She was best friends with Baci, assuming the role of his
little spoon when they would nap together. Her name is
short for *abbracci*, hugs in Italian, and she will reach out
a paw to pat you if she wants your attention. If she is
annoyed, however, she will release a (highly un-catlike)
huff of exasperation.

ABBY

Tug is fine with that.

Nothing much bothers Tug, who has reached a level of zen attainable to few ABCs. A most happy, most recent rescue story, he of the captivating different-colored eyes found his forever home only this summer. Tug had been living with about 60 other FIV+ cats in a no-kill shelter in Georgia, where his human-to-be had begun volunteering nine months earlier. He won her over with his irresistible sweetness.

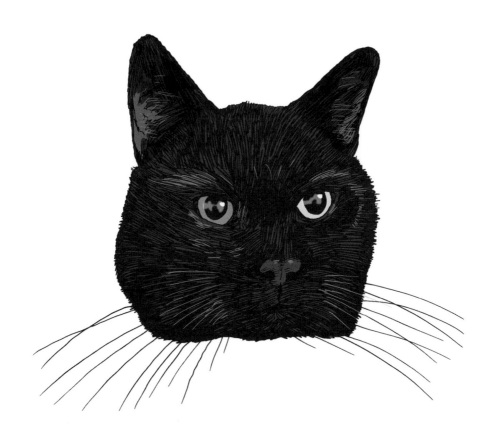

TUG

Fester is pissed.

Fester first came in contact with the Cullen Sheehan
Household by accident: He was the outline of a cat,
quite flat on the road with the exception of a long black
tail, straight up. This was 11:30 on an intensely hot night
in Derry, Northern Ireland, after Tracy hit him with her
car. When she, weeping, went to lift what appeared to
be a poor dead creature to the side of the road, suddenly
the head twirled around *Exorcist*-style, opened its large
blue-green eyes and spat and hissed repeatedly. Tracy
took him home to Donegal. For the next six weeks of
cage care, the cat clearly held a grudge—hence the
name Fester. People would drop by to watch him spit
and snarl and jump the cage across the room like a wild
beast. Fester remained angry to a lesser extent for a
decade. He is now king of all cats, including the three
ABCs (Maidin Mhaith, Irish for *good morning*; Puddles,
found as a kitten floating down the street in a flood;
Jewels Slippers, who eats jewelry and sleeps on
slippers) and one fluffy Persian he lives with, named
OTT, for Off The Table, who is usually on said table.

FESTER

Fig sees dead people.

On a windy day, 11-month-old Fig loves to climb to the topmost branch of the tree in his garden and sway on the branch with the wind in his fur. This may or may not be related to his ghost-spotting — which he does a lot of from the home base he shares with Theresa, Damien and his cat brother Myles in Derry, Northern Ireland. Fig hates the spirit world.

FIG

Tino is a wild card.

An aggressive cat from the very beginning—2001, three
weeks old, eyes crossed and barely open when two boys
in a public school in the South Bronx brought him to
Catherine in a shoebox—Tino has no play mode. For six
years he reigned in terror, going from docile to destroy:
the hand dangling off the sofa, the sleeper with a little
skin exposed, the dark-hallway ambush. Then, on the
recommendation of a cat behaviorist, Catherine and
Dan brought Owen—a younger, kinder, fatter gray cat—
into the house to temper Tino's more psychotic episodes.
The attacks were reduced by approximately 95 percent.
Now 14, Tino is a cuddler, but it is like cuddling with Jack
the Ripper. He does not like much except food: corn
on the cob, Brussels sprouts, black beans, asparagus
(extra like!) and cream cheese. He has retired to the
countryside north of NYC to live out his remaining years.

TINO

Raymond was a star.

Sweet gentleman Raymond, with the Meyer lemon-
colored eyes, lived in Jakarta, Indonesia. His household —
which he initiated with ABC twin brother Carlos by
peeing on all the shoes at the entrance — was shared with
the cats' very strange mustachioed and bad-tempered
mother Ibu and a loving group of humans from the
islands of Maluku and Java and the far side of Angers
in the Maine et Loire. Raymond slept under the sheets
(while his brother slept on top of the bed). He once
broke his leg, believed to be in the act of defending his
mother against the sexual advances of a big, angry male
who bit Raymond. He was around 2.5 years old when
he was killed in front of his home by a hit-and-run driver.
Carlos, who grieved for years, is alive and well in the
neighborhood today.

RAYMOND

Roxy is a small grande dame.

In a two-story colonial home in Lancaster, Ohio, Roxy owns Jenny Clark and Johnathan Smith, along with other humans Morgan, Connor, Drew, Katelyn and Ellie. Her animals are the white Himalayan Fergie; Mac, a cat the color of mac and cheese; and Chesapeake Bay retriever Hogan. She is of Russian ancestry and quite the lady, with a super-flat little face, barely-there nose and featherweight of 6.5 pounds. When she ventures outside it is to chase bugs.

ROXY

Panther/Panth is a pirate.

An ABC of the high seas, Panther, 2, lives full-time on
a sailboat in the British Virgin Islands. She's a fantastic
swimmer, known to go ashore on her own if the boat is
moored close to an interesting island. She loves getting
into the fish bucket and climbing onto the boom when
the sail is down. When she was a kitten, she won the
captain's love and rescue at first sight. Then she ate
an entire stick of butter that had been left on the counter.

PANTHER/PANTH

Rashid/Dr. Startlepants is collecting data.

Science is the driving force in the life of Rashid/
Dr. Startlepants. He is a mad scientist genius who would
rule the world if he could do it from under the covers.
His biggest love and his biggest phobia are the same
thing: strange phenomena. Even before his tail has
returned to normal size, he will sneak up on whatever
he encountered, closely observing its behavior until it
gives up its secrets. He likes vanilla cupcakes and
talking smack at his archnemesis, a crow who sits on
the roof across the street. He lives in Seattle with
humans Beverly and Rick and tabby sister Surya, who
is also his lovely assistant under her nom de science,
Miss Smackwiggins.

RASHID/ DR. STARTLEPANTS

Vano is uptown.

Vano lives in a multigenerational, international Armenian
family—mom, dad, grandfather, sons Haig, 15, Vahan,
12, and sister Nairi, 9—on Fifth Avenue in Lower Harlem,
NYC. He was born two years ago here, along with five
siblings, in the closet. This was shortly after the family had
admired then taken in a beautiful cat who'd been walking
the streets for weeks, secretly fed by their doorman.
How could anyone abandon something so precious?
Within an hour of naming Anoush, it was discovered that
she was pregnant and soon expecting. Vano chases
sticks and balls when you throw them. He likes ice and
even water. A city kid, he shows disdain for the outdoors.

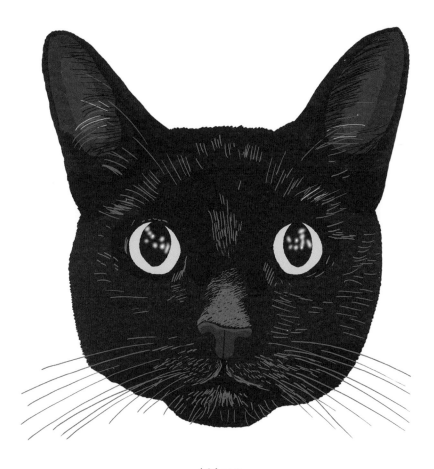

VANO

Acknowledgments – People

First, thank you to every one of our Kickstarter backers for making this real, for making the work so much fun, and for making us laugh—even sometimes without the support of cat videos.

Extra appreciation for those who sprung for the good seats, sponsoring places in the book for ABCs other than their own. That's a lot of money to give a cat. About a dozen ABCs appear courtesy of generous gifts from these people who don't live with them: Jennifer Adler, Padraig Timoney, Larry Goldwasser and Okcha McDonald, Lou Allen, Laurie and Paul Feig, Kevin Lee, John Bennett and Suzanne Fogarty, Suzie Elkin and Pete Borowsky, Ellen Sternau and Jeff McGuckin, Vero Kiermer and George Feely.

A special 50 All Black Cats salute to the most extraordinary friend to animals and humans Stephen Milioti, who sponsored Kim, Ronaldo and Ringo—the three former ABC Meow Parlour/KittyKind shelter cats now in happy new homes.

We're grateful to our longtime friends and brilliant designers Katrin Wiens for her work on AllBlackCats.com, and Martin Perrin of Perrin Studio—whose allergist *still* doesn't know he has a cat—for creating the original design of this book.

Thanks as well to the all-around excellent humans we met at this intersection of, immersion in publishing and personalities and cats: Margot Atwell and the Kickstarter community; Rich Williams and Modko; Emilie Legrand and her colleagues at Meow Parlour.

Once we got to the stage they call fulfillment, we led postally driven lives. Some days contained as many as four trips to the three-window Tompkins Square Station U.S. Post Office. These could have been most unpleasant experiences, but the cheer and charm, stamp strategies and professionalism of Daisy Smith and Lenny Rotaly there made for most pleasant experiences, something to (almost) look forward to.

For adopting All Black Cats—for giving us too a happy new home, house—huge thanks to Kate McKean at Howard Morhaim Literary Agency and Wynn Rankin, aka The West Coast Face of Mimi Goldsparkle, our editor at Chronicle Books. Also ABC CBA (Chronicle Books Applause) to: Pippa White, Alice Chau, Lia Brown, Michelle Clair, Sandy Smith, and April Whitney.

Acknowledgments – Cats

Studio Goldsparkle thanks the incomparable ABCs who contributed to the making of this book:

Abby • A.C. aka AC/DC Back in Black • Acton Bell • Alfie • Ambrose • Angel aka Tail Less aka Water Baby • Arthur Dent • Baby Elmo • Baci • Bad Cat • Bama • Bastet • BB • Bean • Bebe • Bella but we call her Machete • Benjamin • Benny Jones aka Evil Prime Minister of Malaysia • Bentley • Benton • Big Cat • Binks • Black Magic • Blackness/BatWing • Boris • Callie • Calvin • Carlos • Cassie • Charlie Parker • Cheri/Cherry/Jerry • Chibi • Chiquita/Chickie • Chopper • Church • Cinders • Cleo • Clyde • Coco • Daffy • Daria • Darkness • Doyle • Dylan • Emerson • Emmy • Ephron • Eva, aka Boo Boo Kitty F*ck • Fester • Fergus • Fig • Fiona • Foxy Fred • Gamma • Girl Scout • Gomez • Guenhwyvur • Gwenyvar/Gwennie Pie • Hampton • Harold • Homebody aka Hombee • Houdini • Hugh • Iggy Pop • Isak • Jack • James Bond • james | cat • JetGirl aka Jet • Jette/Little Buddha • Kama • Kim • King Louis XV aka Bear Cat • KitKat • Koa • Lovey • Lucky I • Lucky II • Lucifer War Machine aka Lucy • Luna • Mabel • Maddy • Maggie the Peach • Margarita • Master • Max • Miles • Millhouse • Miller • Mimi • Mina • Minton • Miso • Moby Dick • Monty • Nana • Nibbins • Nox • Olive • Oscar • Osito • Panther/Panth • Patrick the Catrick • Peepers née Minnie Pearl • Penelope Kitten • Persephone/Percy • Princess (of Brooklyn) • Princess (of Long Island) • Puddha • Pugsley • Puma • Pumaa • Puzzles • Pyewacket • Pyewackett • Q • Rashid/Dr. Startlepants • Raymond • Reginald • Requiem • Ringo • Rio aka Ratman aka Butthead aka Snagglepuss • Roarke • Rohmer • Ronaldo • Ronin • Roxy • Salem (the Elder) • Salem (the Younger) • Sambuca • Sara • Sashi • Schwartz I • Schwartz II • Sebastian • Seth • Shadow • Sinone aka Princess • Smoky • Sonny • Spanky • Spencer • Spirit • Stella • Steve/Steven J. Stevilmeyer III aka Pete, Steebullah and "What was that sound?" • Storm/Diana • Studio Cat • Sumi • Sushi • Sy • Sylvia • Terza • That Cat • The Count • Theo • Tiburon • Timmy • Tino • Tipper • Toet • Tug • Tzipi • Ursula • Vano • Vincent • Wanda June • Wednesday • Wookie • Yoshi • Yoyobop • Yuki